Gerry Badger

PHA
non n

CHRIS 55
KILLIP

Φ

Chris Killip usually prefers to let his pictures do the talking. But in his recent review of the book *Case History* by Ukrainian photographer Boris Mikhailov, he succinctly defined his attitude to the medium. He praised Mikhailov's uncompromising vision over what he termed 'product', work 'produced for galleries, for Hollywood, produced for the art scene'. No wonder, he argued, 'most of current photography is devoid of content'. These are strong views, and decidedly serious; not so much elitist as high-minded, not so much anti-commercial as anti-pap. The seriousness is essential. Photography is so often blandly superficial that those who cherish it must take it seriously.

However, Killip's criterion for 'good' photography does not mean a blanket condemnation of anything other than so-called 'serious photography'. Far from it. His primary criteria are authenticity and passion, and he will praise the honesty of a commercial job well done before the pretensions of solipsistic 'product' manufactured for the gallery wall. His approval is reserved generally for photographers with strong opinions, and the guts to state them in their work at the risk of being branded unfashionable. He is scornful of those who blithely follow trends, who feign radicalism, who posture.

His championing of Boris Mikhailov is typical. It is generally those photographers who have emerged from left-field (metaphorically and sometimes politically) who gain his approval. His fellow travellers are generally the nonconformists of photography, individualistic, stubborn and quirky — figures of whom the establishment (despite perhaps embracing them) remains faintly suspicious. Along with Mikhailov, we might mention Ed van der Elsken, Nan Goldin, William Eggleston, Helen Levitt, Diane Arbus, Christer Strömholm, Walker Evans, Eugène Atget and Robert Frank. Both as a photographer and as a photographic

figure, Killip fits in comfortably with this diverse crowd, who have two important things in common. Firstly, they are, or were, predominantly loners, standing not so much outside the mainstream as quietly positioning themselves at a slight remove from it. They are photography's mavericks, not in the sense of being wilful nonconformists (petulant bohemians with a camera) but rather in a more fundamental sense of being clear-eyed realists.

Secondly, and crucially, their primary involvement is not with the art world, but with life itself. Whatever their stylistic differences and personal inclinations, their work could never be termed 'product'. It is never devoid of content, and the substance of that content, in a nutshell, is the human condition. Whatever the subjective nature of their imagery (and these people have been among the most personal of photographers), ultimately it deals with history in the sense that it is concerned with how society acts upon the individual and the ineluctable facts of existence. Some of the group — Levitt, for instance, possibly Atget — considered themselves political, with programmed intent. Others — Arbus and Evans — denied a political motive. But among its other qualities — formal beauty, lucid description, complex allusion — their work functions as a passionate witness and is often an indictment of their times, whether as a result of, or in spite of, their best intentions.

This notion of bearing witness, of revealing transgressions, is fundamental to Killip and is a constantly reiterated theme. He called his book on the dark side of Margaret Thatcher's England *In Flagrante* (1988). He muses that he almost wishes he had never seen Mikhailov's shocking pictures, 'and that I was not implicated in them'. To paraphrase Walker Evans, it seems that for Killip an essential component of the photographic mission is the role of 'reporter

inker, spy'. However, that is not a licence for self-indulgent voyeurism, but a moral imperative.

Yet Killip is not one of the new breed of self-righteous moralists seeking to put photography 'in the dock'. He asks only that our reactions be honest reactions to honest images, and that, whether moved to anger or compassion or whatever, we are at least compelled to think and feel. The fact that our reactions are so frequently uneasy only serves to remind us that the best photography first and foremost demonstrates an art of the real – direct and 'devoid of flim-flam', as Evans put it.

Killip's separateness from the mainstream may be attributed to the fact that he is a Manxman – born in Douglas, Isle of Man, in 1946. He left school in 1962 at the age of sixteen, and a year later arrived in London with the aim of making a career in photography. After many rejections, he eventually secured a job as an assistant in the Chelsea studio of Adrian Flowers, one of the most successful advertising photographers of the day.

The best education for a photographer, Walker Evans once wrote, is informal and regular access to a master. The next best, surely, is attained by assistants to successful commercial photographers. Whether one learns about photo-graphic 'art' or not, it provides an exacting and thorough technical grounding that would stand any photographer in good stead, whatever his or her future direction.

Clearly, this monograph demonstrates that advertising photography was not to remain Killip's métier. While on assignment in New York in October 1969, his

ideas about the medium were given a singular jolt. He visited the Museum o Modern Art and saw original prints by the great modernist-documentar photographers, figures like Paul Strand, Walker Evans, August Sander, Rober Frank and Eugène Atget. He was profoundly impressed, seeing here, fo almost the first time, the potential of the medium fully realized. There were few exhibitions of photography in England at that time, and this confrontation witl serious, completely unadorned photography made its inevitable impact.

The MOMA experience was truly Damascene, setting him firmly on the path fror commercial to 'independent' photographer. It resulted in a courageous, ye typically stubborn and clear-sighted choice, which led eventually to his firs major body of work. Apparently throwing away an enviable beginning to hi career, Killip returned home to the Isle of Man. He worked nights in the pub rul by his father and spent the days photographing – documenting a way of life tha had prevailed for generations but which was now under imminent threat. Hi subsequent first book, *The Isle of Man: A Book About the Manx* (1980), woul never satisfy a metropolitan art director's brief. It was not only a dour, unflash exploration of the photographer's cultural roots, but also a subtle polemi against those who were turning the island into a tax haven.

A currently popular issue in photographic theory is whether good photographs and for good read 'true'– stem from those with inside knowledge of a subjec or those objectively removed from it. The new photographic moralists tend t dictate that only those from within a community really have the right to repre sent it. However, it is more generally agreed that good photography stems no from a position of insider privilege, but from having a defined, honest an impassioned point of view. Nevertheless, it seems clear that the success o

Killip's first extended foray into 'personal' photography derived from the fact that he was photographing the familiar. The intensity of feeling he had for his roots overcame the problems inherent in his adoption of such a rigorous style.

Killip's main influence for *The Isle of Man* was the rather venerable American photographer Paul Strand. During the 1950s, Strand had made a series of documentary books on rural communities, in which he combined portraits with environmental studies, making a simple yet profound statement about man's symbiotic relationship with the landscape. Strand's Scottish book, *Tir a' Mhurain*, shot on the Hebridean island of South Uist in 1955, is arguably the most fully realized of these volumes and the obvious precedent for *The Isle of Man*, which follows the same strategy of linking portrait studies with views of the land, the sea, the sky – the whole ecology that shaped those grave, serious faces and their sturdy, elemental buildings.

Like Strand, Killip's study is a paean to a lost world. He has said that: 'The Manx were becoming a minority on their own island thanks to the influx of those in the financial services industry, buying out people from homes they had owned for generations, and this motivated me.' One might think that this suggested a romantic nostalgia, but that would be mistaken. To be sure, despite its sourness, the work of either photographer is essentially romantic, but it is a hard-headed romanticism, tempered with a large measure of realism – downright pessimism even. Some critics have seen an eschatological despair, mounting almost to nihilism, lurking in the dignified textures of Strand's monumental portrait studies. Beneath the finely crafted beauties of Killip's *The Isle of Man* burns an unmitigated sense of waste. Killip had begun photographing the Isle of Man using a 35 mm camera in 1969, but when he showed the

early results to Bill Jay, the editor of *Album* magazine, Jay insisted he use a larger camera. Accordingly, he returned to the island with a 4 x 5 plate camera and continued photographing until 1973, although the book was not published until 1980. He had offers to publish, but felt that, 'at the time there were no printers in England capable of reproducing photographs as they should be reproduced'. Good reproduction, however, was expensive, and it was several years before enough money was found to employ the Meriden Gravure Company of Connecticut, acknowledged leaders in the field of photographic book printing.

In the wider context, Killip's attitude to photography derives from the temporarily unfashionable but obdurate tradition of the social documentary. In a more specific context, it emanates from a brief moment in British photographic history when the notion of the 'independent' photographer was a potent rallying call. Towards the end of the 1960s, British photography slowly awoke from what, in the perceptions of many, had been a long slumber, hidebound by tradition; and although the independent photography movement of the 1970s was, in retrospect, somewhat naïve and half-baked, it was at least a beginning. The great influences of this period were Bill Brandt, a quiet loner who made theatrical pictures of great force, and Tony Ray-Jones. This young photographer had returned from America with a fresh perspective on the foibles of the English and was a fierce advocate of the notion – gained during his American sojourn – that a photographer must follow his own instincts, not those of commissioning editors. The British photographic magazines *Creative Camera* and *Album*, among others, echoed this cry. However, during the hiatus between photographing and the publication of *The Isle of Man*, both Killip and British photography had moved on; but the book still made its impact. It was early work to be sure, but announced a major talent. It was, as critic Ian Jeffrey noted

'a documentary of substance'. And as Jeffrey concluded in his well-judged review in *Creative Camera*: 'It is the first British photo-book since Bill Brandt's documentary studies of Britain in the 30s to be worthy of the name.'

In 1975 Killip moved to the North of England. He was among the founders of the Side Gallery in Newcastle, one of many such ventures in the burgeoning independent sector of photography. The Side was the gallery outlet of Amber Associates, a group of documentary photographers and film-makers whose aim was 'to encourage local photographers, and indeed others of merit from outside the region, to work in the North-East on projects, exhibitions and commissions with the support of the Side'. There was a nominal political agenda, but broadly speaking those involved with the Side remained within the tradition of the humanist documentary rather than the hardcore political. This can be seen by the 'outside' talent commissioned during Killip's tenure as the gallery's director – names such as Martine Franck and Markéta Luskacová.

All this was very much in line with Killip's own thinking, maintaining a clear proletarian viewpoint, yet not rejecting the apparently contradictory goal of formalism and art. As we will see, Killip has never denied that, as well as telling the stories of his subjects, he ruthlessly tells his own.

Walker Evans became a new influence on his work now; subtler, less direct than Strand. Credited by Alan Trachtenberg for introducing 'difficulty' into modern photography, it was Evans who maintained that photography should be about 'paradox and play and oxymoron'. He wanted his images to be 'literate, authoritative and transcendent'. True to those edicts, Killip's North-East work has transcended the specific circumstances of its making.

If Killip could not be described as totally political in the strict sense, his documentary practice nevertheless had a keen edge. This was the North of England in the 1980s. This was the era known indelibly as the Thatcher Years – a decade neatly framed by the three Conservative governments led by Margaret Thatcher, under whose extreme monetarist policies the last vestiges of traditional British industry were all but swept away in a period of vicious change. The country was polarized. As art historian David Mellor wrote, the 'fixities of class, employment, industry and the state were unfixed by a programme of forced modernisation and the unleashing of an unbounded consumer culture'.

Thatcherism was a crusade (unholy to many) and in crusades there are casual-ties – in this case, it was those areas of the country where heavy industry was the economic mainstay, such as Scotland, Wales and the North of England. There was resistance, culminating in the biggest working-class upheaval since the General Strike of 1926 – the Miners' Strike of 1984–5. The crucial episode was the 'Battle of Orgreave', where massed pickets of miners were charged by mounted police in full riot gear. The forces of law and order decisively won the day, and not for the first time the working-class North was consigned to defeat.

During the strike, Killip set aside his personal projects to photograph the struggle. Out of a large archive of images, two survived to be included in his book *In Flagrante*. It is significant that not only was he willing to put his personal artistic ambitions on hold while there was a cause to be followed, but also that he made the clear distinction between different facets of his practice. Between photography as evidence and photography as art.

Almost a decade after it was begun, and following several exhibitions of specific bodies of work – such as his 'Skinningrove' and 'Seacoal' series – Killip's North-Eastern work was gathered together in more or less definitive form in two major exhibitions and a book, all of them defining moments in post-1970s British photography. Firstly, in 1985, a joint exhibition entitled 'Another Country', made with his close friend, the photographer Graham Smith, was shown at London's Serpentine Gallery. Its reception was generally fulsome, but powerful and committed work inevitably attracts dissension, and the first flush of postmodern revisionism was abroad. Work in an apparently traditional documentary vein seemed wilfully old-fashioned, its bitter, authentic ironies somewhat lost on those espousing the rather more ersatz 'ironies' of representational theory. A few, missing the point altogether, even condemned its stereotypical view of the North, cloth caps and all, when there was hardly a cloth cap in sight.

The success of the exhibition, however, lay in the differences between the work of Killip and Smith. The individual personalities of each photographer were strikingly apparent – as indeed they should be – but in the context unexpectedly so. The garrulous Smith seemed a deal more positive, or at least more extrovert, in his vision of the North-East than the more introspective Killip. However, that did not mean the Killip images were without their celebratory aspects, nor that Smith's were devoid of bitterness. Certainly, the collaboration was a great triumph, the last hurrah (and arguably the consummation) of British black-and-white photography before colour subsumed everything. It is a great shame that a planned publication of the exhibits, which was to have been firmly anti-elitist, cheaply produced and in the form of a newspaper, was never published.

Happily, the Killip half of the show was not lost, as a fair proportion of the work seen in 'Another Country' was published three years later in his second monograph, *In Flagrante*, which was accompanied by an exhibition at the Victoria and Albert Museum which went on to tour Europe. Here was a fully realized photo-book by a British photographer; complex, subtle, allusive. It was in the documentary mode, that is to say, realist in tone, but realism shot through and through with a powerful and insistent personal inflection. For Killip, it achieved a long-term goal to make photography which might be perceived in a literary, cinematic way, with a narrative flow, however oblique, and the work of art was the book itself.

In the book's brief introduction, Killip made a statement which encapsulated his approach to photography and explained the difference between these images and the more literal documentary record of the miners' struggle: 'The book is a fiction about metaphor.' This statement needs to be carefully considered. Firstly, Killip is acknowledging the fictive nature of all photography. There is no 'pure' documentary; everything is an interpretation, a mediation – even that benchmark of disinterested transparency, the police mug shot. But that emotive word 'fiction' does not, as many presuppose, imply an untruth. Killip uses the word to confirm that photography, like most visual media, like most art, is largely a fabrication. Killip is essentially a chronicler, of the lives of his subjects, of the North-East or the Isle of Man, of aspects of our culture and, importantly, also of himself. Fiction is merely the genre, but realism and truth are the aims.

Yet it remains truth from a particular point of view, partial and partisan. Killip freely acknowledges this. It is not cameras that speak, but photographers; his subjects would not photograph themselves in the same way. Primarily, it is the

photographer's story which is being divulged, although, like any *auteur*, he intersects it with the individual tales of the subjects which he is interpreting. So what is the substance of Killip's tale, apart from the fact that for certain neglected and ignored sections of British society life is pretty grim, though alleviated briefly by odd redemptive moments?

His work may be viewed as a series of meditations on community. To some, possibly those same postmodern cynics who denigrate the notion of documentary, that may seem outdated, but that is why his work is important, and why it could never be considered 'product'. As the Victoria and Albert Museum's Mark Haworth-Booth, one of Killip's most consistent supporters, has said: 'What has impressed me in recent years is how strongly his images resonate with new audiences ... Who was it that said "poetry is news that stays news"? Anyway, it applies very well to Chris Killip's best photographs.'

Beginning with his own community on the Isle of Man, progressing through various singular communities in the North-East of England, to various communities in the workplace and that perhaps more nebulous community we define as the working class, Killip stresses the possibly vicarious value – but the value nevertheless – of community.

Paradoxically, he usually focuses upon individuals, sometimes families – much less upon large groups of people or obvious communal activities – but that only reinforces the message. The pain upon the faces of those who have no community of any kind, who have lost their sense of community, or whom community has failed, is only too clear in his work. We are born alone, we die alone, but in between, Killip's pictures declare eloquently, we had better stick

together and fight together. If there is any redemption in his work, it is not so much in its formal qualities but in that.

Killip does not photograph captains of industry or Amazonian Indians, but the working classes of Great Britain, because that is the culture from which he comes, those are his roots. And even though he has travelled a long way from those roots, he does not photograph the working classes because he feels either guilt or nostalgia. The desire to bear witness would seem to be a much stronger impulse. Not so much to history, at least not in an immutable, objective sense, for that means history from the winner's point of view. More in the numerous, often oblique ways that photography can enter history, undercutting and subverting orthodoxies.

Killip's contribution to photography, besides the many memorable images, has a number of elements. He proves that there is plenty of life left in documentary. This should not need proving – documentary *is* photography – but the current critical climate deems it necessary. Equally, he is an implacable upholder of integrity in photography, which frequently messes with people's often fragile lives. Killip believes strongly that, while photographers have every right to make personal statements through their work, they should respect those they photograph. And the clearest way to do that is to make photographs that actually *mean* something, not simply add to the overstocked pile of superficial imagery already cluttering our culture.

Killip demonstrates that his photography is essentially a serial medium and takes its cue from life rather than the art world. In this respect it is, perhaps closer to the film or novel than painting. In selecting the images for this book

For example, he was not content merely to survey his career, but to combine known with unknown pictures and create a new bookwork, a new narrative sequence. A new light has been shed on his work by this process. Rigorous documentary may be seen to be suffused with a contemplative inwardness, a rare quality in modern photography.

When he was seven, Killip says, he was admonished by his schoolteacher with this saying, which she then made him memorize: 'The truth told with ill intent is worse than all the lies you will invent.' Chris Killip is not a sociologist with a camera, nor a historian. He is an artist, a poet, with a compulsion to enter people's lives and try and make something of them. To understand them – perhaps. To share his compulsion with us – undoubtedly. To assume the role of advocate – possibly. Or maybe it is all an attempt to reveal something else, both known and unknown. As Killip says: 'I am interested in photographing beliefs, my own and other people's.'

Mr 'Ned' Christian, his Son John and Daughter Brenda, Ballaconnell, Rushen, Isle of Man, 1970. This image, a formal portrait yet also a family snapshot, intro-duces Killip's major themes. He is concerned with community, with relationship between people, whether cultural, socio-political or familial. The last is by n means unimportant. This is a portrait of a Manx family. The Isle of Man is Killip' community, the first he photographed seriously. There is a line in the 'Man Fisherman's Evening Hymn' which goes, 'Come now, O Lord, so that we can se thy face'. A prayer for a Manx photographer, a prayer for any photographer.

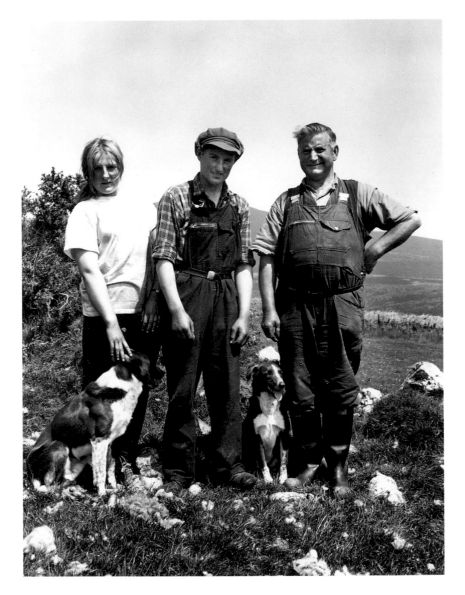

**Geoff Lace Gathering Bent (Marram Grass), The Lhen, Andreas, Isl
of Man, 1970.** Killip's first book, *The Isle of Man: A Book About the Manx*,
about change – existing livelihoods being supplanted by the tax-avoidanc
industry – resulting in the inevitable destruction of a culture. A major leitmot
concerns the documentation of tradition. This cheery fellow in his ex-arm
attire, gathering bent, or marram grass, for thatching, might have appeared i
photographer P.H. Emerson's *Life and Landscape on the Norfolk Broads* (1886
a similar paean to a threatened existence, made a full century earlier. Looking a
this picture, one cannot help but wonder what has happened to thatch gatherin
– and similar trades – since it was taken.

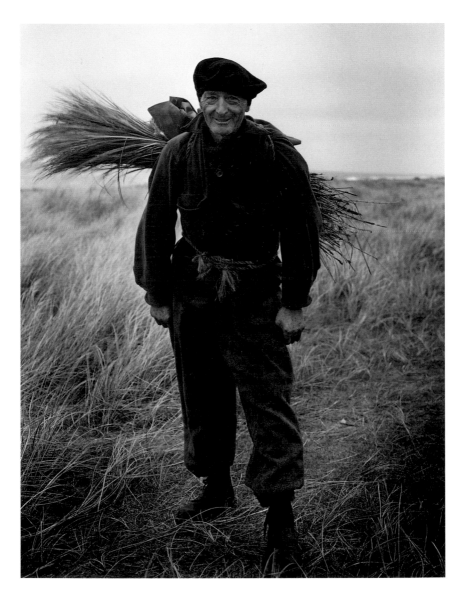

Mrs Pitt, Slieu Whuallian, Glenfaba, Isle of Man, 1971. Some portraitists claim that to include hands in a portrait is to invite problems. Hands can distract from the face, particularly the eyes, those 'mirrors of the soul'. Here, there is clearly an awkward visual dichotomy between hands and eyes, but that makes rather than mars the picture. Both features (and those tight, pursed lips) sing from the same song sheet – telling of a careful existence, determined not only by particular circumstance but also by character and psychological inclination.

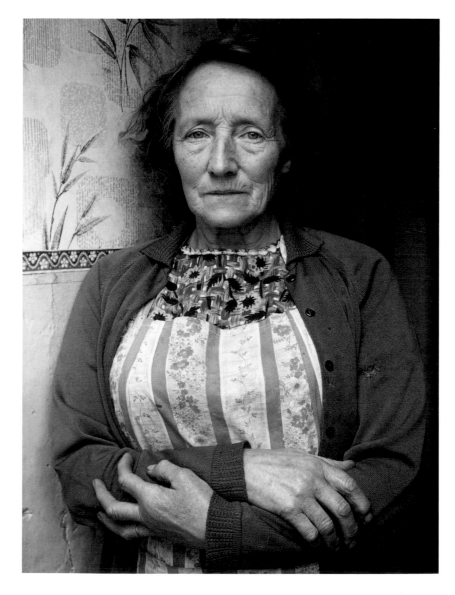

Mr Johnny Moore, Ballalona, Michael, Isle of Man, 1971. Most of Killip's Isle o Man portraits are formal in character. The photographer maintains a respect ful distance and asks us to read the clues provided by gesture and surfac appearance. This portrait of Mr Johnny Moore is quite different, however, an prefigures his later portraits from the North-East of England. It is physicall intimate, structurally fluid, psychologically candid though not judgemental. An as a result of Mr Moore's evident nervousness, its tone is both bleak and dis concerting, yet compelling and touching.

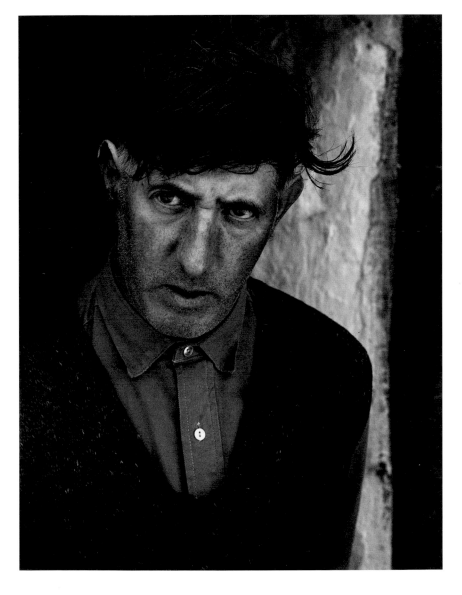

Mr Raddcliffe, The Black Hill, Ballasalla, Isle of Man, 1972. This exhibits all the characteristics of a great formal portrait. It is as severe as a Holbein (or a Paul Strand) and does not reveal its secrets immediately. Killip had access to his subject because he was a fellow Manxman, but Mr Raddcliffe tries to yield nothing to the photographer. Is this a portrait of stubborn pride? Or is he just putting a young whippersnapper in his place by facing the camera as implacable as an Old Testament prophet? One thing is evident: Percy the cat does not soften the picture one iota.

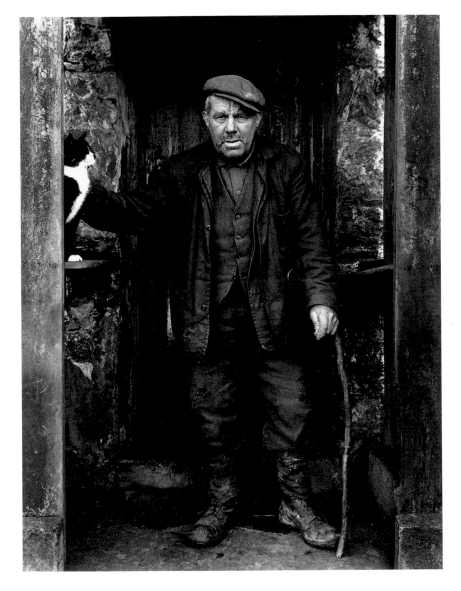

Threshing, Grenaby, Isle of Man, 1972. There is so much happening in this picture of Marshall's giant threshing machine. Firstly, it is a photograph of great formal complexity and beauty. Secondly, it is a document of a traditional rural task carried out in a traditional way. Thirdly, and most importantly perhaps, it is an image that speaks of community – of people working together – of something both ineffable and vital that can be so easily lost if we do not care enough to cherish it and preserve it.

The Golden Meadow Mill Interior, Castletown, Isle of Man, 1972. This is not just a stunningly beautiful interior, calm and evanescent, where form follows function to abstract perfection. A closer look reveals it to be an intriguing visual conundrum. Those oversize scales are loaded up with weights in the right-hand tray, yet it hangs in mid-air, while the empty, left-hand tray almost trails the floor in an apparent denial of the laws of physics. Is this an illusion, or perhaps a comment?

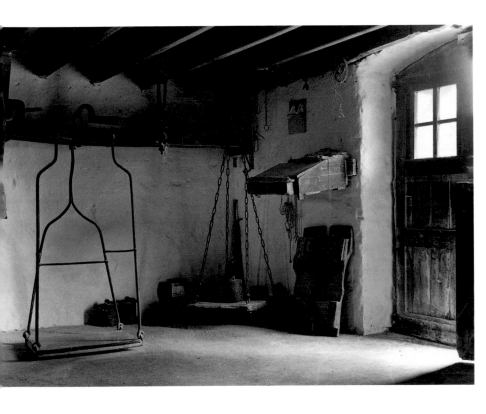

Six of the Skillan Children on their Way to School, Andreas, Isle of Man, 1973. It was Diane Arbus, one of the relatively few great photographic portrait-makers who stated that she always looked for the flaws in her subjects. That is not Killip's way, yet like most portraitists of real insight, he is nevertheless constantly alert for an edge, a way to get under his sitter's skin. Here, it was the tension created by the fact that not one of these children was able to look directly at the camera or the photographer. It makes for an uneasy, brittle picture, but frequently the uneasy portrait implies, or gives away, far more than the defensive aggression contained in the superficialities of the habitual smile.

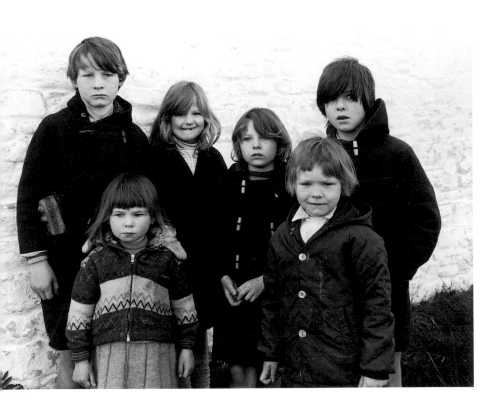

House and Coastal Erosion, Cranstal, Bride, Isle of Man, 1973. Some ma
contend that this photograph of a house being reclaimed by an uncaring se
flirts with the genre of the romantic picturesque. It is certainly a picture abou
tenacity, hope and the failure of hope. But in the wider context of Killip's Isl
of Man, it can be seen also as a metaphor for a social condition — a politica
process — as much as nature's attrition. The image is a powerful symbol of
process which dictates that, in the matter of market as well as natural forces
there are inevitably losers as well as winners.

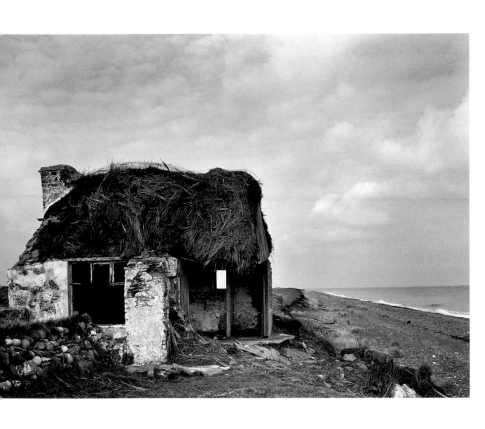

Whippet Fancier, Huddersfield, UK, 1973. Some photographers concern them selves determinedly with the contemporaneous; others seem to focus unerring upon that which is about to disappear. The latter course does not necessari mean a propensity for nostalgia, just concern and a realization that whatever photographed, as soon as the shutter is clicked, it is history. So melancho is perhaps photography's natural state. Breeding whippets and greyhound is probably a dying art. It might seem a clichéd view of life in the North o England, but Killip's measured approach ensures a finely poised portrait tha contains a measure of sentiment, but is properly devoid of sentimentality.

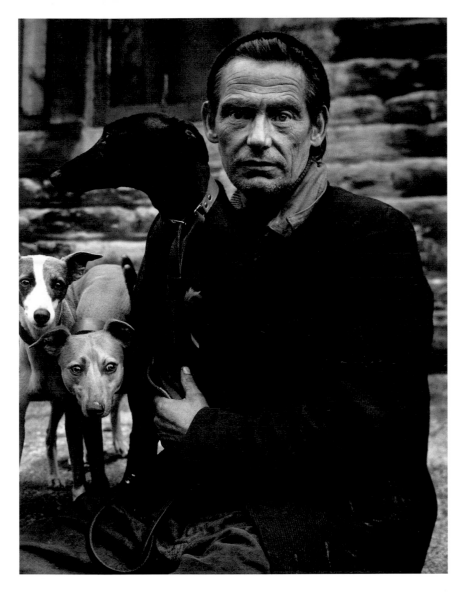

Brass Band Member, Huddersfield, UK, 1973. Brass bands – like whippets – are another supposed Northern cliché from Killip's Huddersfield study; and yet surely they are important, a significant indicator of community vitality and cultural values. This is another carefully judged image that keeps overstatement firmly at bay. Suggest to this young man – cradling his well-used and well-loved instrument with a fierce intensity – that brass bands are old hat and a more than dusty answer will be undoubtedly and deservedly forthcoming.

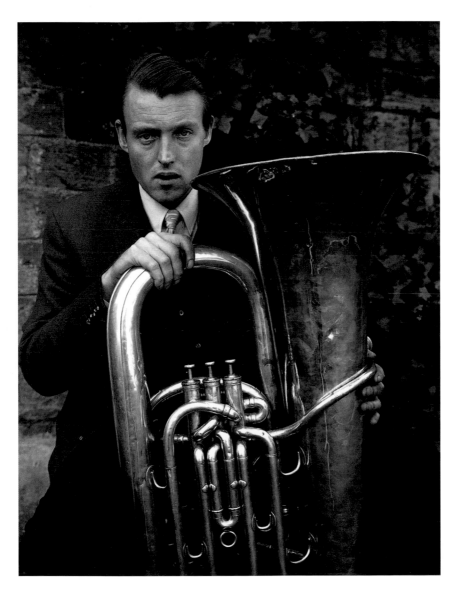

Children's Playground, Huddersfield, UK, 1974. One might say that Killip is no so much a documentary photographer in the accepted sense as a portraitist an a landscapist. People in his imagery are defined by place. Places are defined by people, and he is acutely attuned to that interaction. As critic Ian Jeffrey ha written, Killip works 'with an eye to human potential and to an ideal which i sometimes embodied in the landscape, sometimes in its inhabitants'. This scruff playground, surrounded by structures emitting all kinds of noxious fumes, ma not be ideal but it is potential, modestly realized, and it will have to do.

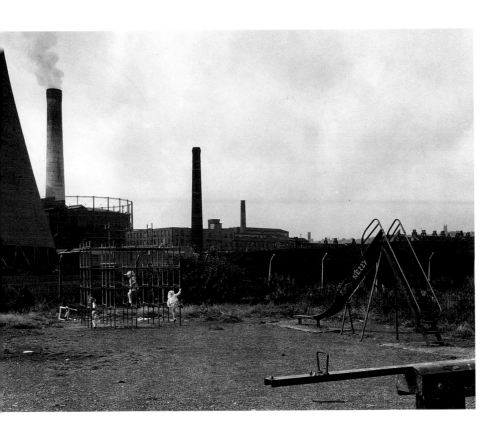

Bingo, West End, Newcastle-upon-Tyne, Tyneside, UK, 1975. A child, blowin
furiously on her hands to keep warm, is left out in the cold by a mother snared b
the lure of a bingo prize. Perhaps. Whether that is the simple fact of the matte
or not, the image certainly speaks powerfully of both exclusion and temptatior
In Killip's hands, another everyday scene becomes a narrative drama, a chapte
in a larger tale, as detail piles upon detail – the lonely child, the crowd inside
the mysterious, blurred caller, even the graffiti-strewn alley, which he was s
right to include in the picture frame.

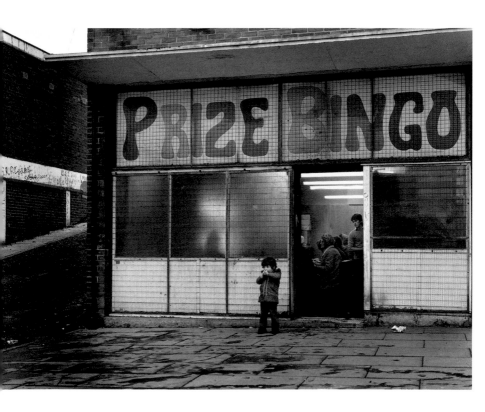

Youth on Fence, Middlesbrough, Teesside, UK, 1975. A youth at a loose en sits on a fence in front of a neglected council house, perhaps taking a furtiv drag behind a cupped hand, perhaps fiddling with his fingernails. This could be scene from Anywhere, England, in the late twentieth century. It is a familiar an depressing scene, which could easily be the stuff of bathos, but Killip has caugh a gesture, a body language – in the gawky attempt at insouciance undermined b the sidelong look away – that transcends the documentary fact and gives it, as i all his photographs, an *attitude*.

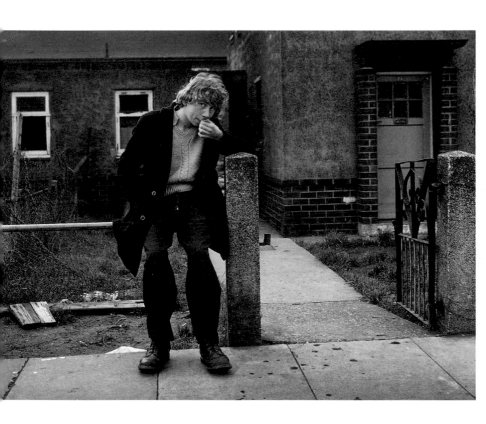

True Love, Gateshead Town Centre, Tyneside, UK, 1976. Ian Jeffrey ha described Killip as an 'ironist' who likes to use photography's tendency t beautify. Killip, however, would appear to be too serious, too genuinely heartfel for the disinterested cynicism of irony. Gallows humour, though, is perhap a different matter. This picture may be the closest he has come to the ironi shrug. A man stands mysteriously before a wall in the shadow of a high-ris block of flats. A whirlwind of paper rubbish blows by. On the wall is chalke 'TRUE LOVE'. Irony? ... not really. This is a truly heartbreaking image.

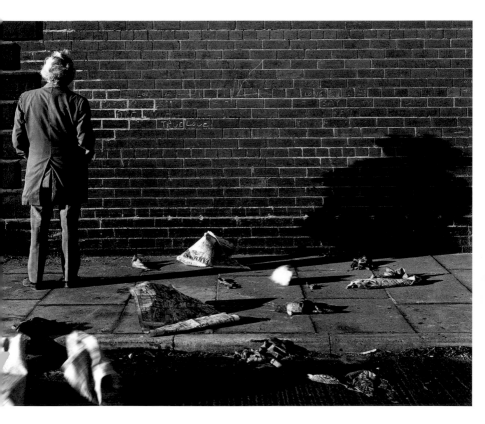

Youth on Wall, Jarrow, Tyneside, UK, 1976. Looking at the anguished boc language, Doc Martens and shaved head, one might jump to the glib conclusic that he is a glue-sniffer, but this is simply a threadbare schoolkid, cold an bored. However, it is those oversized boots, too large for his scrawny frame which draw us like a magnet. Known sometimes as 'bovver' boots, they are b turns menacing and bathetic, symbolizing at once the aggression and vulnerabi ity of youth. A further resonance surely derives from the fact that the pictur was taken in Jarrow, such an emotive place name in the social history of Englanc after the march made in 1936 by shipyard workers to demonstrate against th massive unemployment in the area.

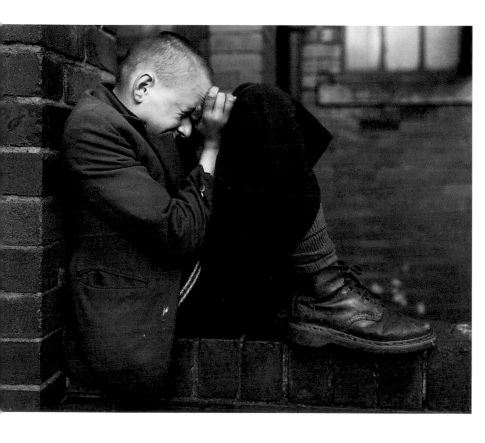

After the Pub, Sunday Afternoon, Whitley Bay, Tyneside, UK, 1977. This is a finely choreographed image, tracing an intricate web of relationships, set in a seaside resort just east of Newcastle. As Killip describes the scene, the men have just arrived back from the Sunday lunchtime ritual, the pub. The women had been left to look after the children on their day out at the seaside. Killip had caught the moment of reunion, when the two worlds collide.

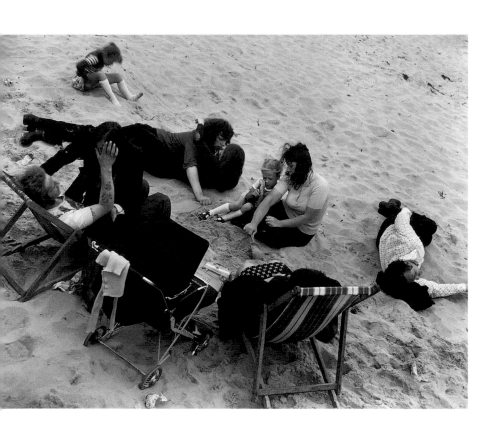

Torso, Pelaw, Gateshead, Tyneside, UK, 1978. This image was once rejected f[]
a German exhibition on the photographic portrait. It was 'not a portrait' since []
did not show its subject's face. But if a less formal definition of portraiture tal[]
of human existence, this is a superbly successful portrait — of an individual ar[]
his life. The clues provided by the shabby clothing and poignant signs of sel[]
neglect compel us to construct a reading about old age and its vicissitudes.

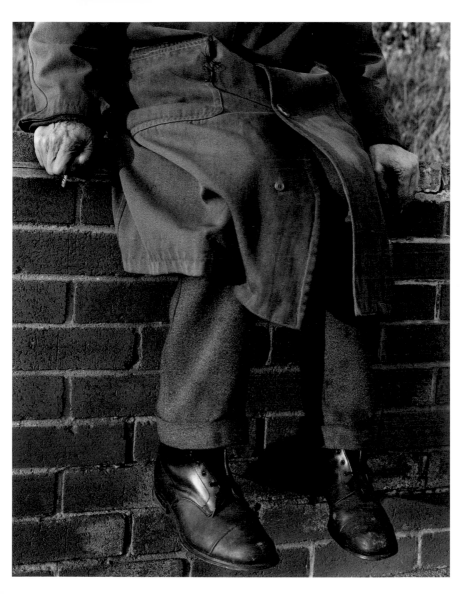

Girl Collecting Money for Guy Fawkes, Gateshead, Tyneside, UK, 1979. 'A penny for the Guy?' is not heard on our streets as often as it once was. Pennies do not go very far towards the purchase of fireworks, and public firework displays have become much better value. 'Spare some change, please?' is the universal urban cry of our times. Despite the nominal Guy Fawkes, one suspects that the plaintive little girl, with her brittle smile and scuffed knees, is perhaps now more familiar with the latter street refrain.

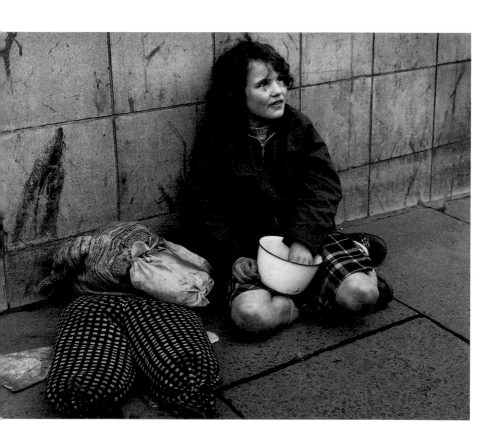

Father and Son, West End, Newcastle-upon-Tyne, Tyneside, UK, 1980. It wa
Roland Barthes who devised the notion of a photograph's 'punctum', the thin
that 'pricks' or 'wounds' the viewer. There can, of course, be more than one. I
this image of a father and son watching a parade with rapt attention, severa
nominally insignificant features stop us short, as Barthes describes. The hand
of both father and son, for example, or the way each is looking at somethin
different. The child's smile too, is charming, but our gaze must always return t
the picture's heart, to that wide, completely unselfconscious smile, all teet
and gums.

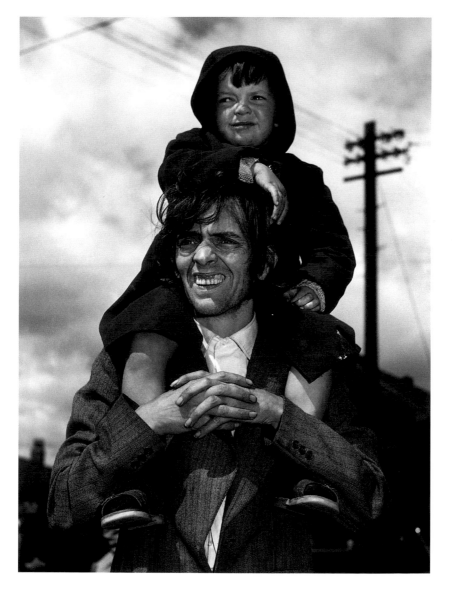

Tyne Ferry, South Shields, Tyneside, UK, 1980. A group of men stand talking the stern of the Tyne Ferry. In the background, a small tanker glides by, pa a row of shipyard cranes. That describes the picture's subject matter. I subject, its metaphorical content, however, is not what is factually recorde The image would appear to allude to loss – loss of jobs, loss of an industry what was once a great shipbuilding area, and so on. But even that tells only pa of the story. Words cannot express how Killip has transformed these basic fact how he has created meaningful visual form out of raw subject matter and h own feelings.

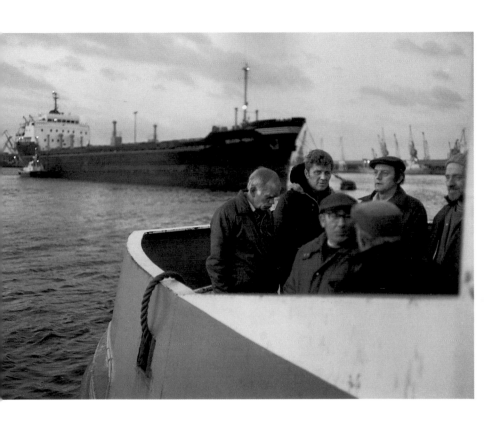

Bever, Skinningrove, North Yorkshire, UK, 1980. The curator John Szarkowsk remarked that describing a photograph in words is a foolish task, in the pursui of which no two fools would ever agree. This image, which introduces an impor tant group from the fishing village of Skinningrove, is utterly mysterious, dense beautiful and true. It depends almost entirely upon mood, but what mood? I could be anything from elation to despair, and all points in between. But looking at the rest of the sequence, it certainly seems to be Skinningrove – or at leas Killip's view of the place. The small fact that the picture was taken at five in the morning may or may not be relevant.

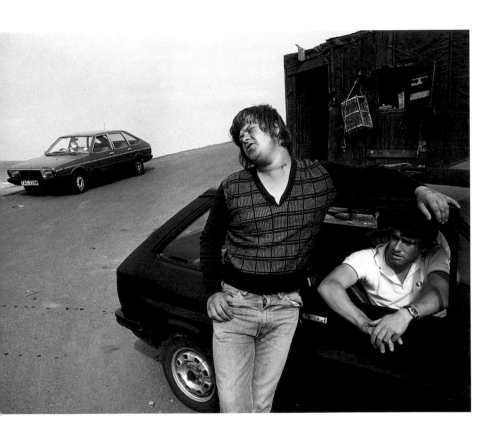

Leso and Gun, Skinningrove, North Yorkshire, UK, 1980. Skinningrove is a smal unlovely fishing village between the Tees conurbation and the 'model' port c Whitby to the south. Skinningrove does not draw coach parties of tourists lik Whitby, but Whitby does not draw Killip. Now increasingly hemmed in by gentrifi cation and the idealizing of the coastline in the interest of holiday homes Skinningrove remains defiantly working class – like a 'sink estate' among fishin communities. 'Skinningrove', say knowing locals, 'is where they eat their babies And this whole sequence, indeed, suggests that Skinningrove is a place on th edge, hence Killip's attraction to it. The gun is used by the 'Grovers' to threate outsiders who stray on to 'their' fishing grounds.

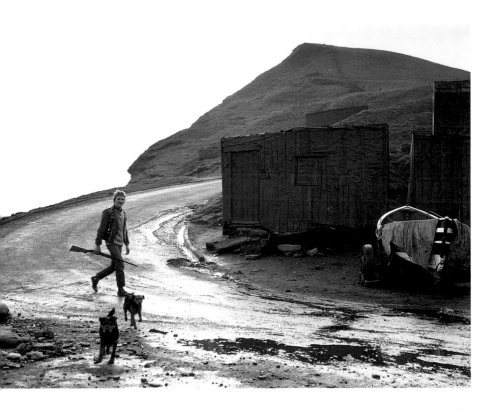

Leso on Motorbike, Skinningrove, North Yorkshire, UK, 1981. In this unsettlin image, desultory inactivity is fused with unease, even menace. Fishing consist of long stretches of boring inactivity, waiting edgily for the right conditions t put to sea. It is a repetitive, obsessive and of course sometimes dangerou occupation. Leso, the rifleman, and Killip's friend, seen previously paddin across the same few yards of concrete (on page 61), was drowned in the freez ing water some time after this photograph was taken. His crewmate Bever wa washed ashore alive, but young David, who was with them, also drowned. Thei mates had to endure watching this brief, cruel drama from the shore, unabl to help.

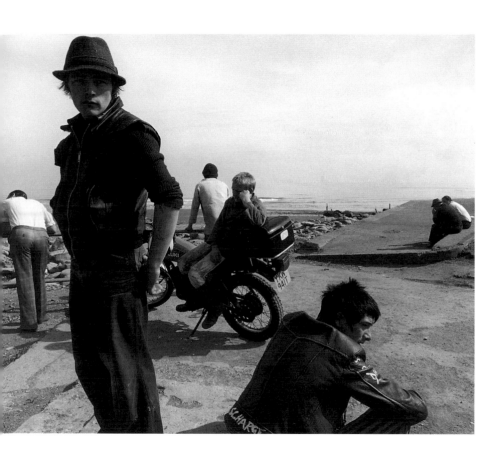

Crabs and People, Skinningrove, North Yorkshire, UK, 1981. Killip, for all hi pessimism, is always willing to find, or create, a redemptive beauty in the mos unpromising territory. The few square yards on the Skinningrove foreshor yielded this sequence — a small area representing a lot of stalking on th photographer's part, for the pictures were taken over three years. The compo sition is more harmonious than that of its predecessor, but the action is keener free from the boredom and palpable unease. Both the dogs and the watcher i the checked shirt have perked up, the dogs for no reason in particular, the ma because he is waiting for the boats' return, a time that produces feelings c anticipation tinged with anxiety.

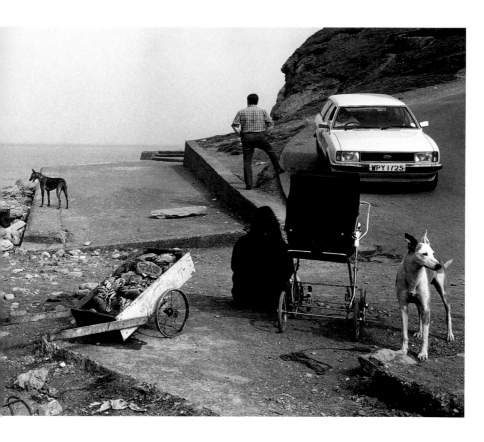

Dawn, Skinningrove, North Yorkshire, UK, 1982. This run of sea-watching images grows calmer and more contemplative in mood, ending with an unashamedly celebratory view of gently rolling breakers in the dawn light. For no matter how scruffy the village, there is always the sea, and for the fisherman however clichéd the sentiment, it remains, in the words of John Masefield's poem 'Sea Fever', 'a wild call and a clear call, that may not be denied'. However this frankly romantic tenor, as usual in Killip, is undercut (just a little in this case) by a hunched figure on the left, who may be scavenging from the detritus on the foreshore, but is more probably wary of turning an ankle on the rough ground.

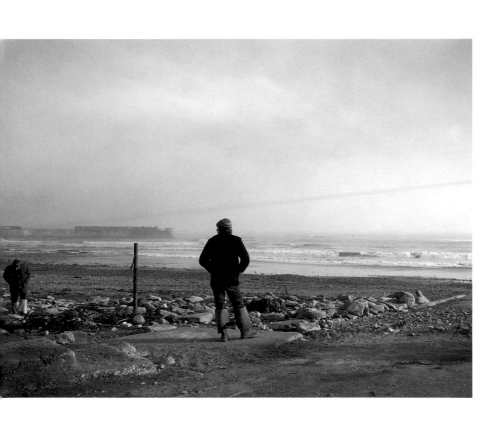

Boats on Foreshore, Skinningrove, North Yorkshire, UK, 1982. There is no harbour at Skinningrove, just the remains of a breakwater. So the boats are hauled straight up on to the beach, a tricky and sometimes tragically dangerous manoeuvre. In this image, the severe lines of the rain-spattered railings in the foreground deny us any possibility of a conventional reading, barring us from easy entry into the picture space. We are forced to peer over at a cluttered, inchoate scene beyond – not a picturesque harbour but a working space – to all intents and purposes, an industrial yard. For Killip it is an anti-pictorial celebration and, by turns, a severely romantic meditation.

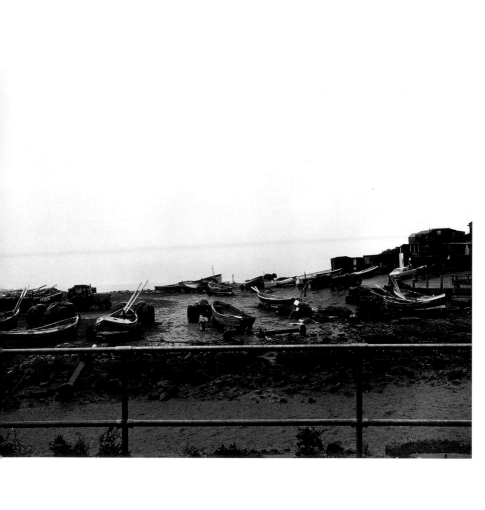

Blackie and Mate at Sea, Skinningrove, North Yorkshire, UK, 1982. If the previous image, and the Skinningrove series in general, is determinedly gritty, it concludes on a note of quiet affirmation, as calm as the shimmering sea from which Blackie and his mate are returning. For a photographer, everything begins and ends with light, and sometimes all a photographer can do – all a photographer *needs* to do – is respond to it. Fishing is no easy way of making a living, but a day like this is surely what any fisherman lives for. And in the North-East, there is something special about the quality of the light.

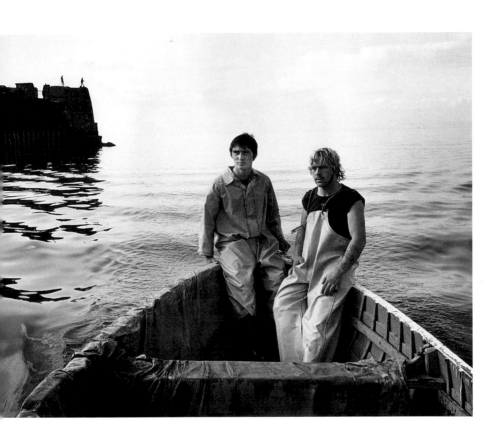

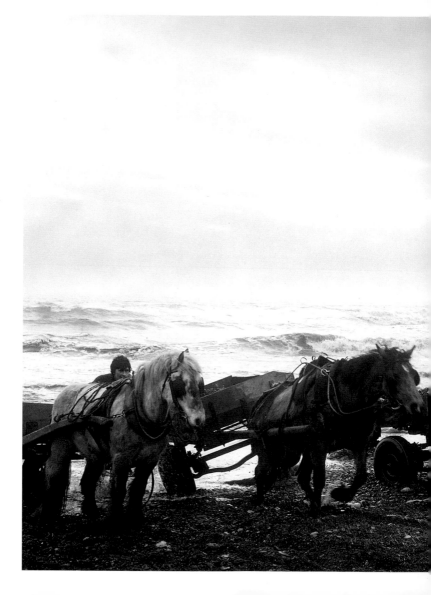

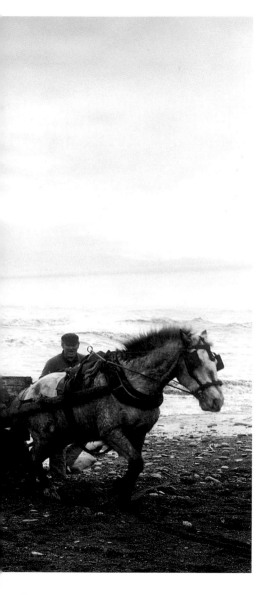

(previous page) Seacoal Beach, Lynemouth, Northumberland, UK, 1982. Thi\
frieze of three horses drawing carts on a windy beach introduces anothe\
community and another important leitmotif in Killip's work. The strange scen\
looks like some arcane ritual from another time – a race, perhaps – but the realit\
is much grimmer. These men (and woman and children) are collecting seacoa\
from the beach at Lynemouth, a large colliery village some 15 miles north c\
Newcastle. Seacoal gathering is a harvest of waste, the recycling of the residu\
from the dumping into the sea of uneconomical coal waste from the nearby min\
by the National Coal Board.

Seacoal Beach, Lynemouth, Northumberland, UK, 1982. Over the course c\
time, the action of the sea separates any coal contained in the waste and th\
tides wash it back on to the beaches at Lynemouth. People living nearby hav\
traditionally made extra money from collecting this coal and selling it, but by th\
early 1980s, when Killip was photographing there, a camp had been set u\
among the dunes, home to local, as well as itinerant, coal gatherers. At one tim\
around forty people attempted to make a living here, forming a hunter-gathere\
community with a complex web of alliances, rivalries and economic relationships\

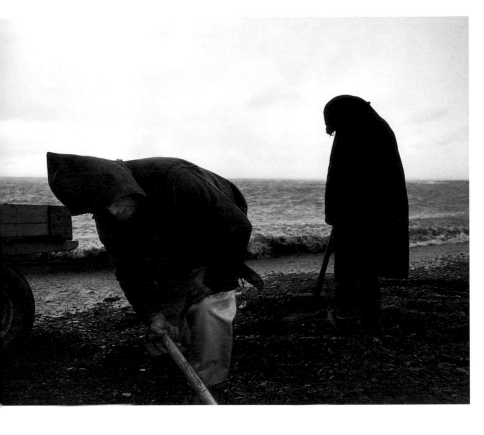

Brian at the Fence, Lynemouth, Northumberland, UK, 1983. Despite the har
and meagre living scratched out by the seacoalers (at the time, they earned
pound a cartload), as always there were those eager to deny them even this.
February 1983, Killip received a call to say there was trouble at the camp. Alca
who owned the local aluminium works, had built a fence to prevent access to or
of the beaches. This photograph shows something of the seacoalers' desperat
protests but, inevitably, the conglomerate Goliath defeated a disorganize
penurious David, and the fence stayed.

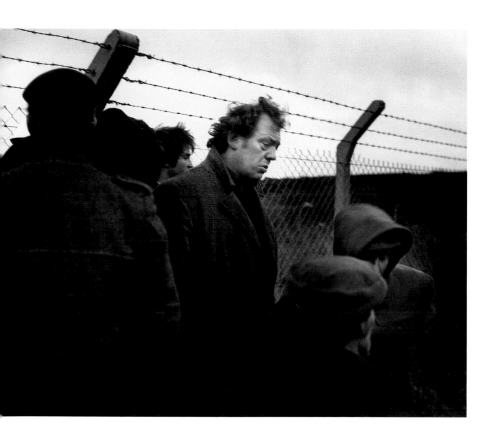

Alison and Dog, Seacoal Beach, Lynemouth, Northumberland, UK, 1983. Kill lived in the seacoalers' camp and was able to photograph life from the insid capturing moments of intimacy, like this image of Alison playing with her dog on dull and dreary day. Despite all the bickering that can exist in an itinerant cam where the living is precarious, such a picture reminds us that, however roug and ready, the seacoalers' camp was a *community*. Their goal was not, as som local councillors would have it, to offend gentility and create an eyesore, but feed themselves and their children.

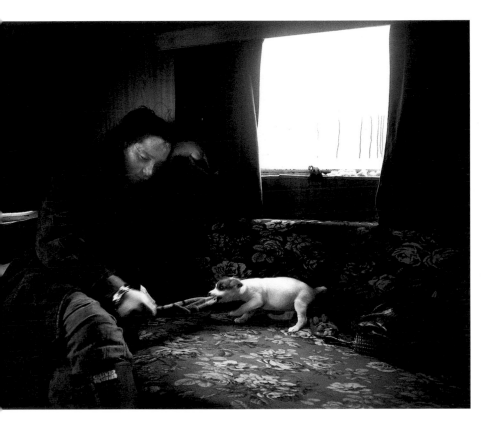

Rocker and a Toad, Seacoal Beach, Lynemouth, Northumberland, UK, 1983
The critic Max Kozloff has remarked that 'nothing is more typical of so-calle
concerned photography than the brutality of its compassion'. This truism i
another way of saying that many 'concerned' photographers are sentimenta
and monosyllabic in tone. Killip will admit to more complex motives — bas
curiosity for one. And he is not afraid to be gentle, as in this picture of youn
Rocker, avidly explaining the differences between a frog and a toad.

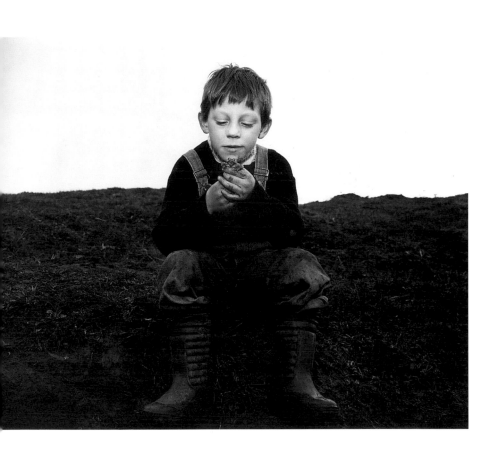

Men and Boys, Seacoal Beach, Lynemouth, Northumberland, UK, 1984. Kill
has stated frequently that his pictures are as much about him as those h
photographs – a relatively rare admission of honesty in a photographer. Of th
image, he remarks that, when a child, he only ever went out with his father in th
evening on one occasion. He was ten years old, and his father took him to se
Charlton Heston in the film *The Ten Commandments* (1956).

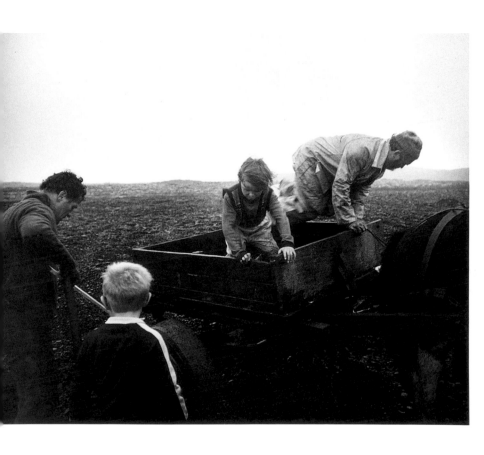

'Cookie' in the Snow, Seacoal Beach, Lynemouth, Northumberland, UK, 1984. A
curator Mark Haworth-Booth has written, this picture is about endurance.
is also about loss, both states describing aspects of the human conditio
Regarding this photograph, one of his most memorable, Killip offers a thoug
from the book *Architectural Reflections* (1992) by Colin St. John Wilson: 'We ar
inside or outside, or on the threshold between. There is no other place to be.'

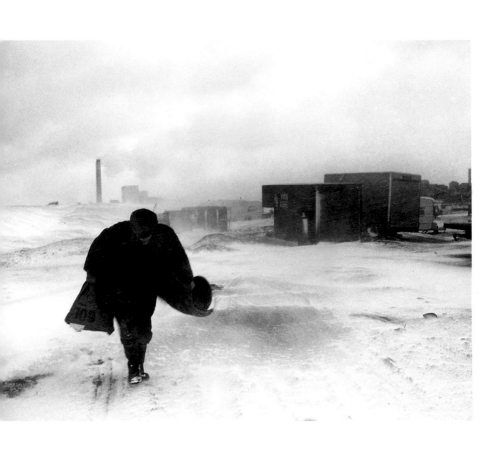

Rocker and Rosie Going Home, Seacoal Beach, Lynemouth, Northumberland, UK, 1984. This is another of Killip's finest images, used as the cover image for his 1988 book *In Flagrante*. As with many of his best pictures, words are wholly inadequate to describe it. Except to say that, like the previous image, it is about survival; furthermore, it is as clear an exposition of the disparity between hope and experience as can be found in photography. It is also a perfect realization of the photographer's aims, to reveal certain elusive facets of the human spirit.

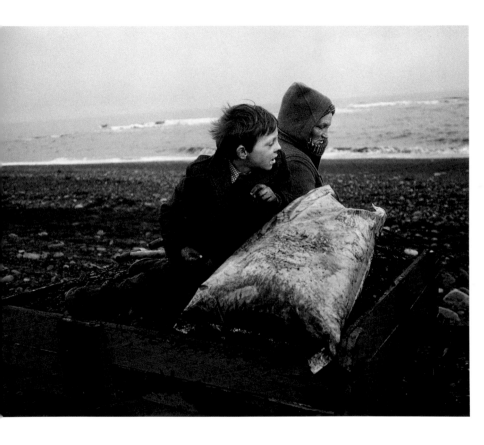

Helen and Hula-hoop, Seacoal Beach, Lynemouth, Northumberland, UK, 198

This is another picture, so deceptively simple, casual even, in which Killip finds
redemptive beauty in the wasteland. One is tempted to speak of this image
formal qualities – the sense of space in the frame, the adroitly tilted horizon
for its psychological qualities are more elusive, so clearly touching yet qui
ineffable. It is a picture about grace, of course, but to say anything more specif
would be to run the risk of sounding glib and sentimental.

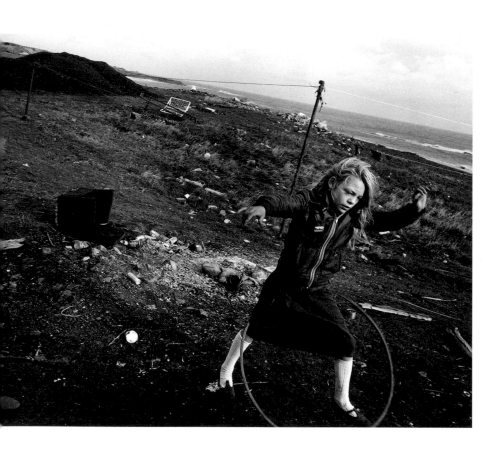

Angelic Upstarts at a Miners' Benefit Dance at the Barbary Coast Clu **Sunderland, Wearside, UK, 1984.** This is not a dance, it is actually a fight, thoug at a punk concert, divisions can get a little blurred. That, however, is hard the point of the image. If one says that its virtues are primarily formal, that is t understate completely the vivid exuberance of its rhythms, the ebullient, swirlin arabesque described by those heaving bodies. This is one of those perfec 'decisive moments' where, upon first glimpsing the negative, the photographe simply gives thanks for a *result*. In this case, doubly so, for the picture was sho on a relatively slow, unwieldy 4 x 5 camera.

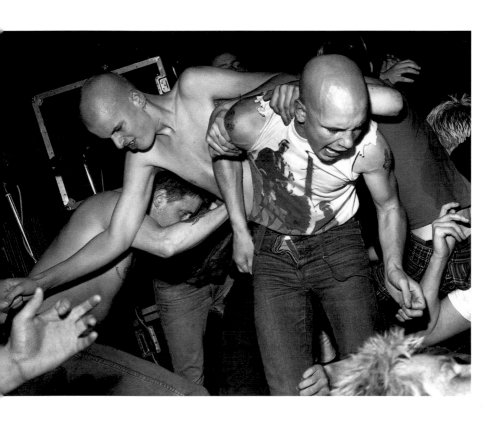

Man Burning Rubbish, Lynemouth, Northumberland, UK, 1984. Here is anothe
image where it seems that Killip might be in allegorical, even apocalyptic mood.
sinister figure – in reality an ordinary man, not some hideous Nibelungen dwa
– burns rubbish. There is all the potential for metaphysical speculation in th
beautiful picture, but it seems clear that, like his mentor Walker Evans, Kill
finds not just disquiet but reverie among the shards of our civilization of wast
That makes him, like Evans, a complicated photographer – and twice as movir
and troubling as any simplistic alternative.

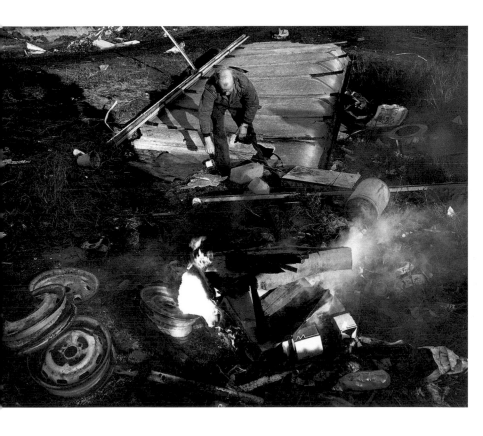

Punks Dancing, Gateshead, Tyneside, UK, 1985. Like *Father and Son* (page 55
and *Woman in Room* (page 97), this picture is about people who are rapt – out o
themselves. The fact that, in this case, their out-of-body experiences migh
be chemically induced is neither here nor there. It could just be the music. O
another level, this image might be considered an allegory for our times. W
crowd together yet have little time for each other. We have devised myriad way
of selfishly withdrawing into our own, individual worlds.

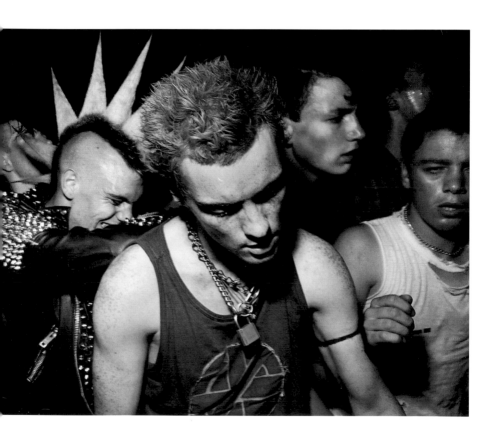

Woman in Room, Williams Street, North Shields, Tyneside, UK, 1986. Sometime a picture moves us because it is indescribably mysterious. The expressic on this woman's face, caught waiting in this room, is unfathomable. It seem impossible to tell her age (one could guess at anything within a three-decac span), her mood, indeed anything of her sentient being except that she is s deep in thought that she is a perfect illustration of the expression 'miles away Each time ones looks at this image, one forms a different conclusion as to he state of mind, a factor that makes this portrait wonderfully full of life.

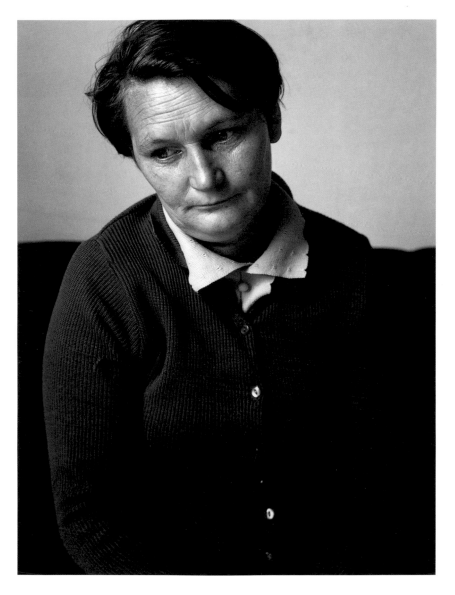

Fallen Man at Bottom of Stairs, Middlesbrough, Teesside, UK, 1987. Killip has knack for making telling little psychodramas out of the most ordinary incidents even non-incidents – of everyday life. This picture was taken on the day that th residents of an old Salvation Army hostel were moving into a new, purpose-bui building. This long-term resident was overcome by the experience and fe down as he was starting up the stairs. He was unhurt but unable to move fc five minutes. Then he got up and struggled to carry on with his day. End of story

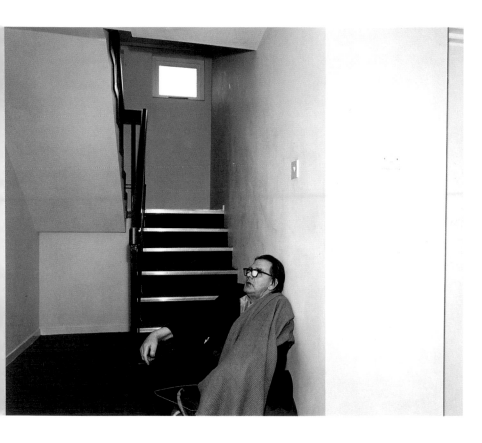

Man on Bench and Sparrows, Wallsend, Tyneside, UK, 1988. This is another picture that explores old age and loneliness, another of those Killip photographs which mediate between portrait and landscape genres. Amid a bleak, contingent landscape of plywood boarding and scrawny trees, this elderly gentleman – seated on a bench that looks more sculptural assemblage than seat – seems not displeased to see the photographer and his paraphernalia. The sparrows – fast disappearing from the urban scene – are less interested.

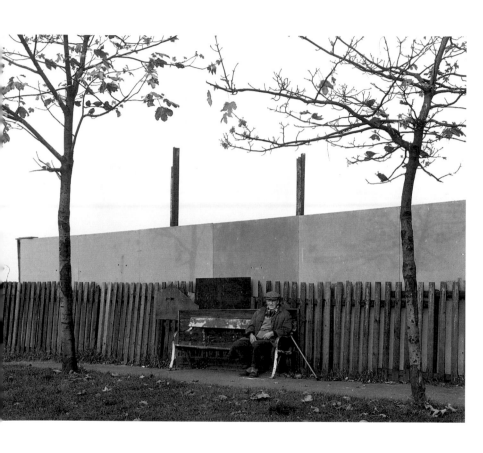

Tyre Factory Worker, Pirelli Ltd, Derbyshire, UK, 1989. In 1989 Killip wa
commissioned by Pirelli to photograph the workforce at their tyre-making facto
in Derbyshire. He was determined to photograph using natural light only, b
discovered that the process is light sensitive, the rubber is black, that th
workers wear dark overalls and that the factory is dimly lit. After four month
of typically stubborn effort, Killip eventually resorted to flash and, probab
because of the trials he had endured, was able to produce an outstandir
series of portraits.

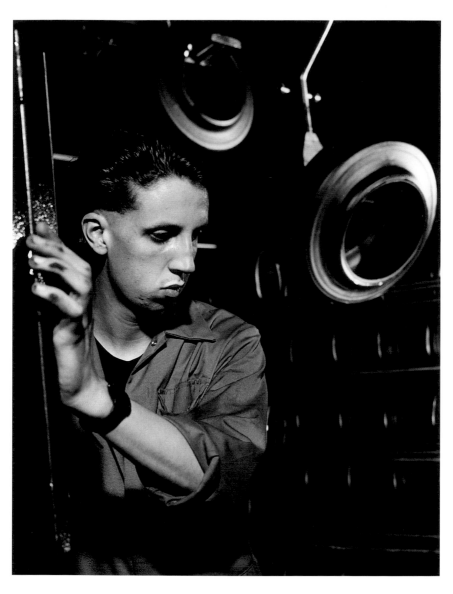

Tyre Factory Worker, Pirelli Ltd, Derbyshire, UK, 1989. For photographer attempting the subject of people working, there are two reference standards the heroic pictures of workers made by Lewis Hine in the 1930s, and th disturbing, downbeat pictures of Lee Friedlander made in the 1970s, where th workers seem to be melded to, or trapped by, their machines. At Pirelli, Killi suceeded in steering a middle course between the two by concentrating nc upon 'workers', but upon individual human beings.

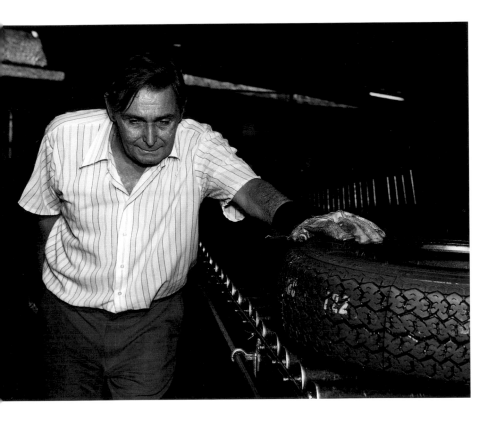

Tyre Factory Worker, Pirelli Ltd, Derbyshire, UK, 1989. Killip says that the Pirel
commission caused him a certain amount of anxiety and soul-searching. A lot c
his creative energies to date had been given over to the struggle of peopl
looking for work and recording the despair of those who were out of work
retired from work, or who had never worked. Now he was required to put asid
all his real misgivings about factories and multinational corporations and tackl
the day-to-day reality of 'this thing called work'.

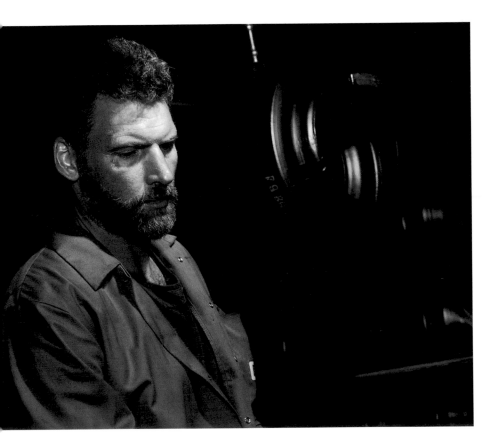

Tyre Factory Worker, Pirelli Ltd, Derbyshire, UK, 1989. The great temptation when photographing work is to try and dramatize what for most of us is essentially routine, a boring and repetitive yet necessary part of our lives — and not just because we need to put food on the table. Work, the sense of being useful, gives human beings a necessary dignity, a grounding in society — feelings carefully and soberly captured by Killip in this series.

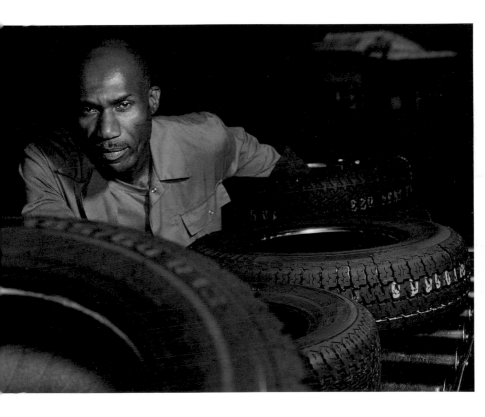

Tyre Held Aloft, Pirelli Ltd, Derbyshire, UK, 1989. Given his tendency to seek ou a number of (but not too many) brief moments of transcendent beauty anywher he photographs, it is no surprise to find Killip doing so in the Pirelli factory Here, the fleeting juxtaposition of an arm and a tyre makes for an image tha looks heavenward amid the factory darkness, a picture that has certain affini ties with that well-known image by Robert Frank on the cover of his boo *The Lines of My Hand* (1971).

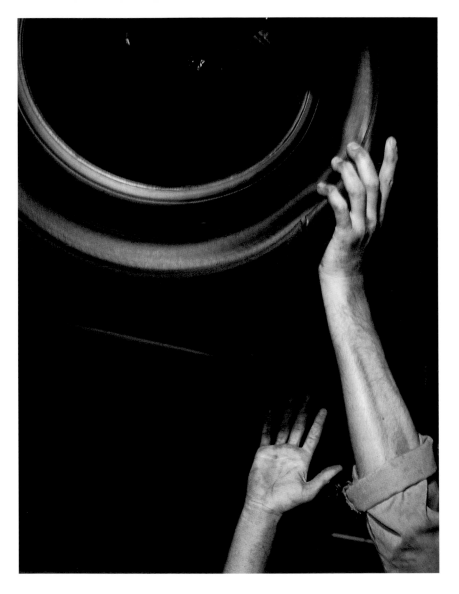

Building Site Worker, City of London, UK, 1991. The next two images come fro[m] another workplace commission. Killip was invited to document the constructio[n] of the City of London headquarters of the law firm Clifford Chance. Here we ha[ve] what might be termed a Lewis Hine moment – a building worker lost amid th[e] apparently unbridled chaos of a large building site – a not infrequent feelin[g] among construction workers.

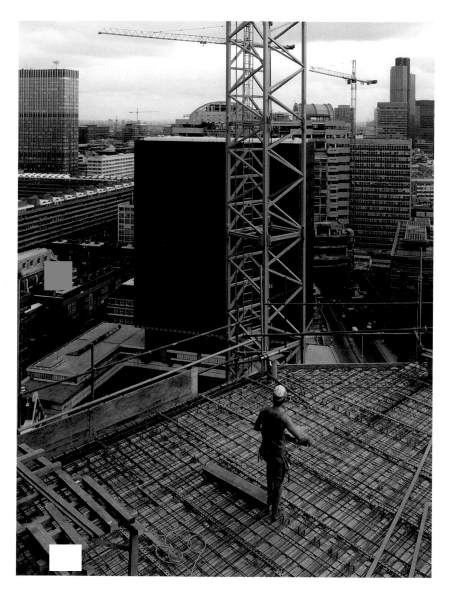

Mason on Building Site, City of London, UK, 1991. Here, on the other hand, we have the Lee Friedlander moment from the Clifford Chance document, where a 'brickie' laying concrete blocks seems to be determinedly building himself into a corner. This is an example of the fact that, despite a photographer's best intentions, documentary frequently turns to allegory and metaphor. In this case, we perhaps have multiple choices for the substance of the allegory.

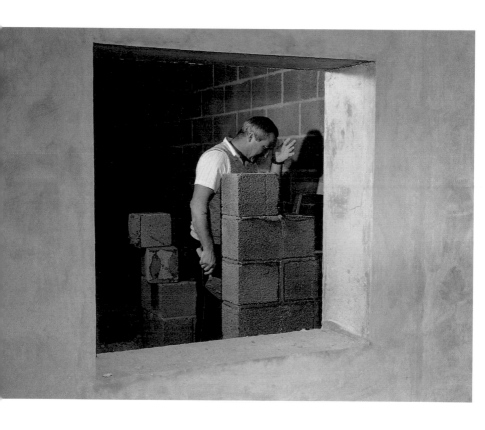

Slave Ship Tableau, Wilberforce Museum, Hull, UK, 1991. An exhibit from the Wilberforce Museum in Hull introduces a number of images from a series in progress that might be described an Alternate History, the flipside to King, Country and Empire – an alternative to the accepted history of power and glory. Of course, all of Killip's work is made with a keen sense of these 'other' histories – of the working classes, of minorities, of outsiders and mavericks and also of the many different ways photography can enter history. But this series is arguably the first formal statement of that fact, in that it is about history's *representation*.

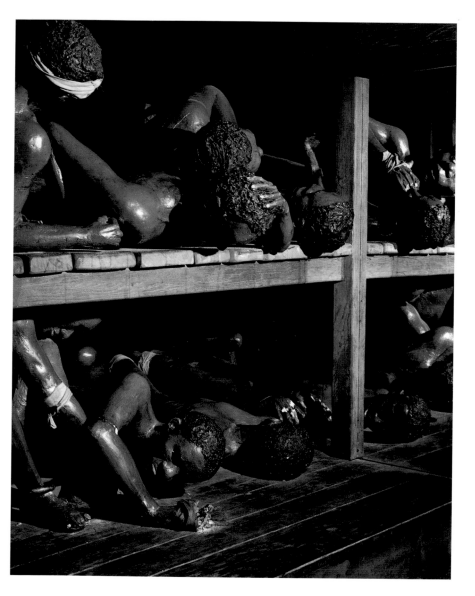

(previous page) The Library of Chained Books, Hereford Cathedral, Hereford UK, 1992. Killip's photographs, as a number of critics have noted, enable us to become storytellers. He utilizes photographs as building blocks in a larger narrative structure and has spoken of photography as a kind of literature. This dissecting of evidence – in a word, knowledge – is the essence of his approach as a photographer. He wants to reveal, or at least allude to, the truths that are swept aside. A little learning is a dangerous thing, it is said. It is also liberating, hence the necessity to chain books – and people.

Prison Cell Under Edinburgh Castle, UK, 1993. This grim cave, oozing with fetid atmosphere, is out of bounds to tourists visiting Scotland's premier monument, as it has been used to incarcerate dissenters within living memory. The guard who showed it to Killip mentioned that some of the 'Red Clydesiders' were held in this appalling place following the great workers' protest of 1919 in George Square, Glasgow – also known as the 'Bloody Friday Riot'. At some point, this unpalatable fact will become digestible, becoming acceptable history for tourists, and part of their itinerary.

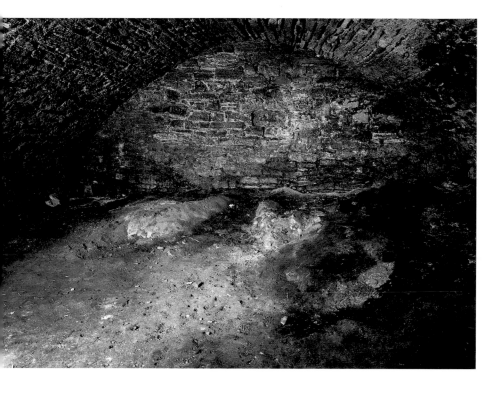

Postman's Park, Barbican, City of London, UK, 1994. Although he has a great affection for the medium, photography in the abstract is not the driving force behind Killip's work. He is interested in what the camera might tell us about our existence. 'If all the cameras or film became unobtainable tomorrow, I would still find a way to address those things I'm interested in,' he has said. Here, for the benefit of those who cannot go there in person, he uses the camera to bring us a commentary on a few sad memorials to ordinary lives, immortalized in the Postman's Park Cemetery in the City of London.

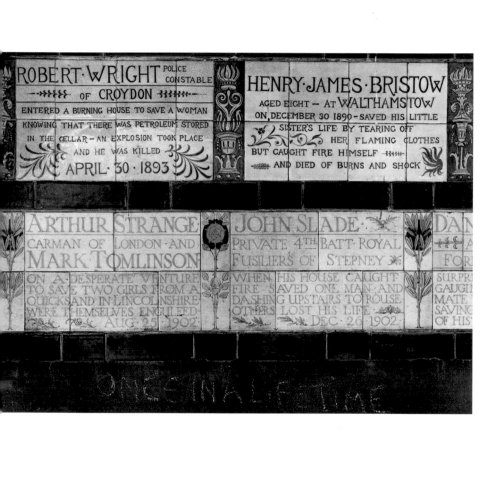

ROBERT · WRIGHT POLICE CONSTABLE OF CROYDON ENTERED A BURNING HOUSE TO SAVE A WOMAN KNOWING THAT THERE WAS PETROLEUM STORED IN THE CELLAR – AN EXPLOSION TOOK PLACE AND HE WAS KILLED APRIL · 30 · 1893

HENRY · JAMES · BRISTOW AGED EIGHT – AT WALTHAMSTOW ON · DECEMBER 30 1890 – SAVED HIS LITTLE SISTER'S LIFE BY TEARING OFF HER FLAMING CLOTHES BUT CAUGHT FIRE HIMSELF AND DIED OF BURNS AND SHOCK

ARTHUR STRANGE CARMAN OF LONDON · AND MARK TOMLINSON ON A DESPERATE VENTURE TO SAVE TWO GIRLS FROM A QUICKSAND IN LINCOLNSHIRE WERE THEMSELVES ENGULFED AUG · 25 · 1902

JOHN SLADE PRIVATE 4TH BATT ROYAL FUSILIERS OF STEPNEY WHEN HIS HOUSE CAUGHT FIRE SAVED ONE MAN · AND DASHING UPSTAIRS TO ROUSE OTHERS LOST HIS LIFE DEC · 26 · 1902

DAN
A
FOR
SURPRI
GAUGI
MATE
SAVING
OF HIS

Croagh Patrick, County Mayo, Ireland, 1995. This last picture shows a crowd of individuals struggling up to the top of the holy mountain Croagh Patrick. Like many of Killip's images, its emotional tone is ambiguous. The Old Manxman in *Moby Dick* could read the future, and the future was dire, but with Killip it is difficult to be so sure. Certainly, this image can be seen as a summation of his concerns – the place of individuals within the larger community of society, the continued need for hope despite the lessons of bitter experience and the fact that, despite the reality of frequently rough and stony ground, most human beings have little choice other than to carry on climbing their personal mountain.

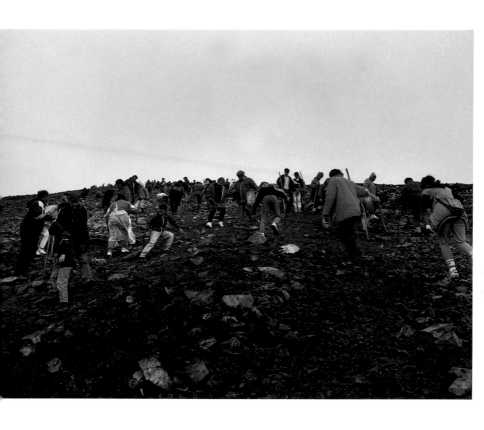

1946 Christopher David Killip is born in Douglas, Isle of Man.

1962 Leaves Douglas High School for Boys.

1964 Moves to London and becomes assistant to the advertising photographer Adrian Flowers.

1969 Works as a freelance photographer in London. Inspired by a visit to the Museum of Modern Art, New York, where he sees prints by modernist documentary photographers such as Paul Strand and Walker Evans, he quits commercial work and commits completely to his personal photography.

1970 Returns to the Isle of Man and works at night in the pub run by his father and spends his days photographing.

1972 Commissioned by the Arts Council of Great Britain to photograph two cities – Bury St Edmonds and Huddersfield – for the exhibition, 'Two Views – Two Cities'.

1973 *The Isle of Man* limited edition portfolio published by Witkin Gallery, New York.

1975 Receives a two-year fellowship from Northern Arts and moves to the North-East of England. The magazine *Creative Camera* devotes a whole issue (May) to his early photographs from the region.

1976 Founder member of the Side Gallery, Newcastle-upon-Tyne. He is the gallery's director 1977–9. Remains their exhibition curator and advisor until 1984.

1977 His son Matthew is born.

1979 Photographic consultant to *London Review of Books*.

1980 *The Isle of Man: A Book About the Manx* is published with a text by John Berger.

1984 The exhibition 'Seacoal' opens at the Side Gallery before touring the North of England.

1985 'Another Country', a joint exhibition of work from the North-East with his close friend the photographer Graham Smith, opens at the Serpentine Gallery, London, to critical acclaim.

1986 Exhibition at the Art Institute of Chicago, USA.

1988 Second major book, *In Flagrante*, with texts by John Berger and Sylvia Grant, is published. The French edition, *Vague à l'âme*, is published in Paris the same year. The exhibition 'In Flagrante' opens at the Victoria and Albert Museum, London, before touring extensively in Europe.

1989 Wins the Henri Cartier-Bresson Award. Commissioned by Pirelli Ltd to photograph their workforce.

1990 An exhibition of these photographs, 'Working at Pirelli', is shown at the Victoria and Albert Museum, London.

1991 'Chris Killip Retrospective' exhibition opens at the Palais de Tokyo, Paris. Commissioned by the law firm Clifford Chance and Co. to document the building of their new City of London headquarters. Moves to live in the USA.

1996 'The Last Art Show', exhibition of commissioned work on Jarrow, Bede Gallery, Jarrow, England.

1997 'Chris Killip Photographs, 1971–96', Manx Museum, Douglas, Isle of Man.

2000 'Chris Killip: Sixty Photographs' exhibition opens at the Old Post Office, Berlin.

2001 Continues to photograph, particularly in Ireland and the North-East of England. His current work is mainly in colour.

Photography is the visual medium of the modern world. As a means of recording, and as an art form in its own right, it pervades our lives and shapes our perceptions.

55 is a new series of beautifully produced, pocket-sized books that acknowledge and celebrate all styles and all aspects of photography.

Just as Penguin books found a new market for fiction in the 1930s, so, at the start of a new century, Phaidon **55**s, accessible to everyone, will reach a new, visually aware contemporary audience. Each volume of 128 pages focuses on the life's work of an individual master and contains an informative introduction and 55 key works accompanied by extended captions.

As part of an ongoing program, each **55** offers a story of modern life.

Chris Killip (b.1946) is one of Britain's most important social documentary photographers. He has worked mainly on long-term, historically valuable photographic projects. Born on the Isle of Man, his most important work includes a series of portraits of his fellow islanders. His images of the North-East of England won him the coveted Cartier-Bresson Award in 1989.

Gerry Badger is a photographer, architect and curator. His books include monographs on Atget and Paul Graham. He currently teaches history of photography at Brighton University.

Phaidon Press Limited
Regent's Wharf
All Saints Street
London N1 9PA

Phaidon Press Inc.
180 Varick Street
New York NY 10014

www.phaidon.com

First published 2001
©2001 Phaidon Press Limited

ISBN 0 7148 4028 9

Designed by Julia Hasting
Printed in Hong Kong

Chris Killip would like to thank the following for their support: Clifford Chance and Co., the Dean of Hereford Cathedral, Pirelli Ltd and the Wilberforce Museum.